THE MEDICINE OF PLACE

Thank you for your
support

Chuck Lawood

J. Vincent Harten

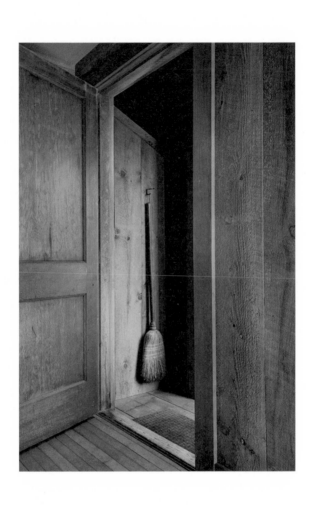

THE MEDICINE
OF PLACE

A Collection of Epigrams
And Easy Essays

Text by: J. Vincent Hansen
Photography by: Chuck Norwood

NORTH STAR PRESS OF ST. CLOUD, INC.
St. Cloud, Minnesota

ISBN: 978-1-68201-070-9

Printed in the United States of America.

First edition: July 2017

Published by
North Star Press
19485 Estes Road
Clearwater, Minnesota 55320
www.northstarpress.com

For my Mother and Father
and for all the others
who stayed home.

"When Truth heard of these things, He sent a message to Piers telling him to take his team of oxen and till the earth and He granted him a Pardon from guilt and punishment, both for himself and for his heirs forever. And He said that Piers must stay at home and plough the fields, and whoever helped him to plough or plant or sow, or did any useful work for Him, would be included with him in the Pardon."

Piers Ploughman
William Langland
(c. 1330 – c. 1400)

Wisdom returns—

not to stay but to retrieve.

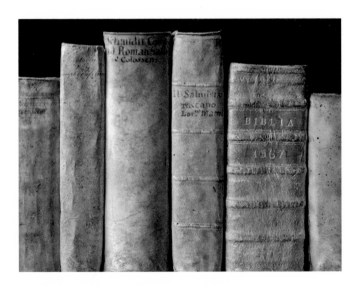

EASY ESSAY CCCIII

for Henry and Stella Ludwig

But for tradition we would have
no way to speak to those who came
before us—more costly still, no way
to second their motions.

A Prayer

En route to our sufficiencies,
might we never lose sight of others.

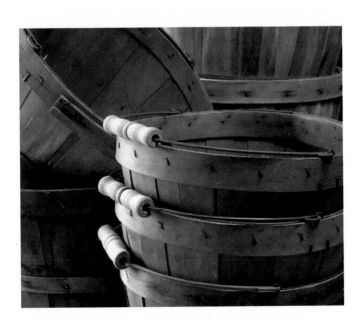

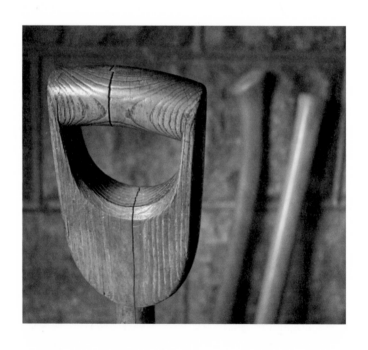

EASY ESSAY CCLV

for Ronald Vierkant
(1922–2012)

It is Good Work spiced with Risk
and marinated in Honest Sweat
that equips us at the end
with Worth-whileness.

EASY ESSAY CXXII

Neither by possession nor receipt
is a tool made one's own but rather
in the shaping of the handle.

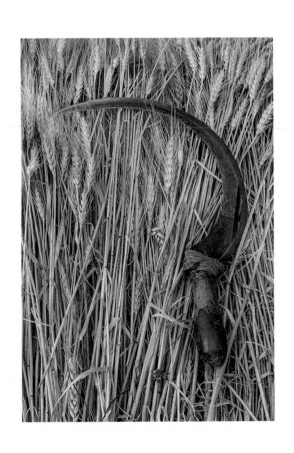

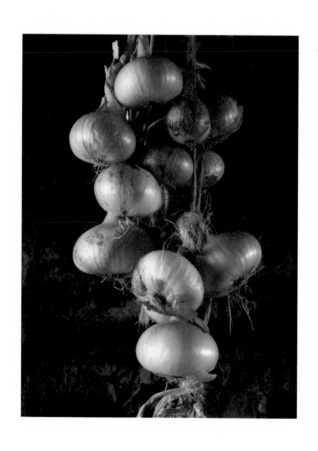

All but the farmer

come late to the feast.

GRAVEDIGGER

Through a warped fence we
watched the widow Wade lower the
small brown bodies into the moist
ground, watched as she tamped the
damp little graves with all her eighty
pounds, then again in October, when
she returned with gunnysack
and spade.

for Laverne Dehler

Dirt under our nails—
this is the noble franchise
Earth offers.

In defense of everydayness.

We dismiss Routine at our own peril, for little of value takes place ouside the rut.

EASY ESSAY CLXXXIX

for Leo and Frances

A stirring thing it is to witness,
the pulling together of Routine
and Ritual with Tradition in tow.

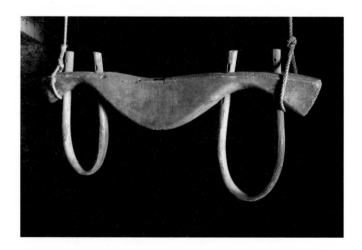

LAST WILL AND TESTAMENT

A defiant
Bantam cock
manages to free
a single wing,

then testifies
on the birch tree
with a thousand
tiny red specks

of his desire
to live.

Hog Butchering

In a scalding rite
of rural benediction

from the Farmall seat
at my father's command

I raise and lower
the flaccid pink corpse.

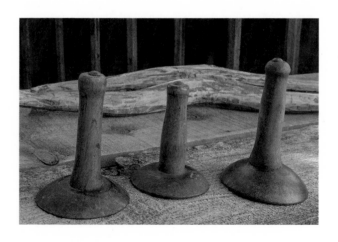

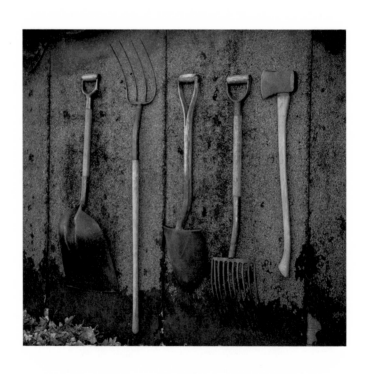

for Wendelin
and Helen Hansen

To none are we more
beholden than to those
who came and went and
left the handles golden.

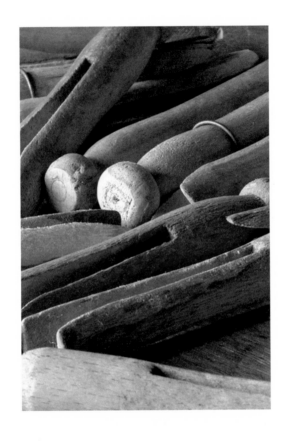

for Edwardine Siebels O.S.B.
(1903-2002)

We dissect humility
and always it is we come
upon the small chore.

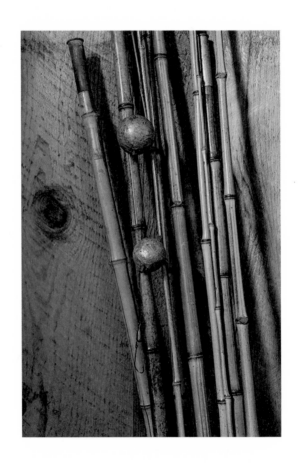

for Jim Pundsack

To beaver away and on another occasion to bask—both are ours.

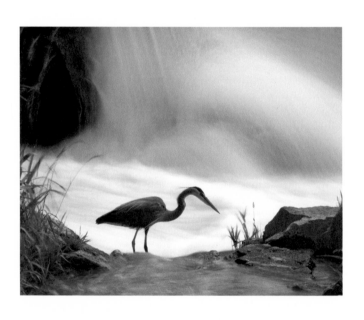

for Larry Schug

Should we slow down
enough, Nature has agreed
to hold our breath.

EASY ESSAY CCLVII

for Anna Akhmatova

(1889-1966)

What poets fear most is that they
will entertain—that silence will fail
to drown out applause in the wake
of their verse.

for Maurice & Rita
Palmersheim

We were given
words for the foothills,
music for the slope,
silence for the peak.

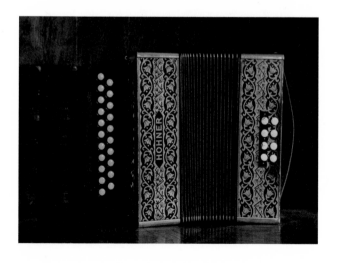

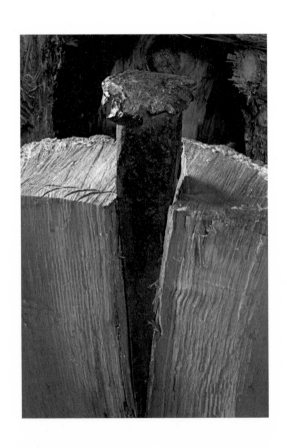

EASY ESSAY CCVI

for Pauly Studenski
(1906–1970)

A bonus for felling the trees,
splitting the rails and setting the
posts is knowing which side of
the fence to come down on.

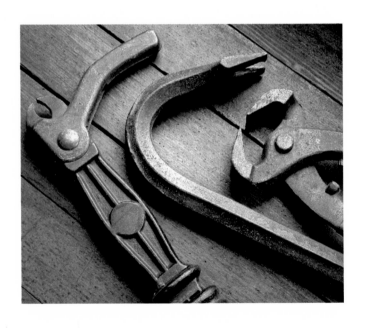

EASY ESSAY CXCV

I do not seek for myself
an unspoiled place—give me
instead an earlier dream played out,
one foreclosed on by both man and
nature and by honest sweat and
sixteen-hour days; I will bring it back,
for there is none higher than the art
of salvage.

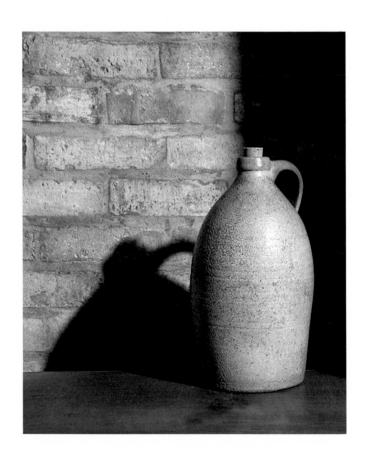

"Throw all that tin along with that brick
into the dumpster."

Overheard

THE LAZARUS WALL

On a bed of sand,
late into the night,
Jeanette and I chip away
at the loyal mortar
of the bricks' first marriage.

One by one
we stack the clean brick
onto the bed of the old truck—
our doing made light now
by the image in our minds
of the chimney and new wall

born of the yellow brick
thought dead.

To build is to *have the floor*—
we ought be careful what we say.

EASY ESSAY CXXXIX

A dream
minus tools
equals a dream.

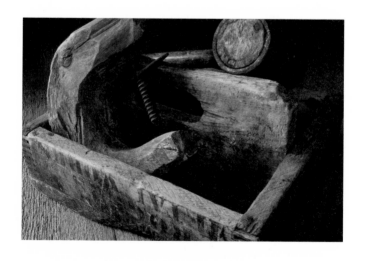

Smallness is testimonial
whereas bigness by its nature
is confessional.

EASY ESSAY CLXXV

How a man builds tells me what
I need to know of him; what he builds,
what I need know of his god.

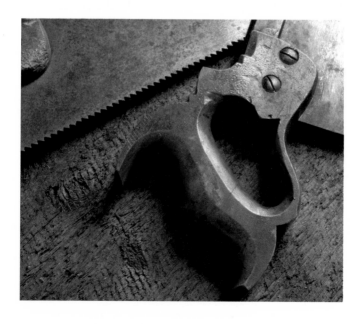

EASY ESSAY LXXX

The burden of the architect
lies in keeping the *feature*
from becoming a *symptom*.

EASY ESSAY CXC

Architecture ought never
to say: *look what I have replaced,*
but rather: *look what I have become
a part of.*

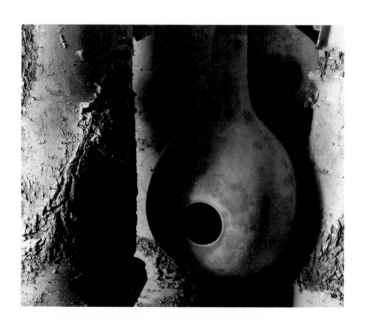

Easy Essay CCXLV

We must come to hear *scale* for there are those among us who have no other way to inform us that they are lonely.

EASY ESSAY CCLXXII

Ignore appropriateness and
the blueprint becomes a lie—
the tool an accomplice.

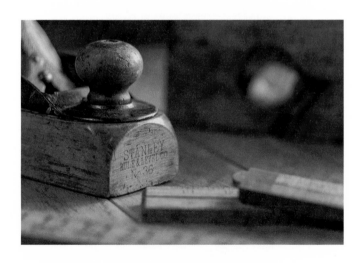

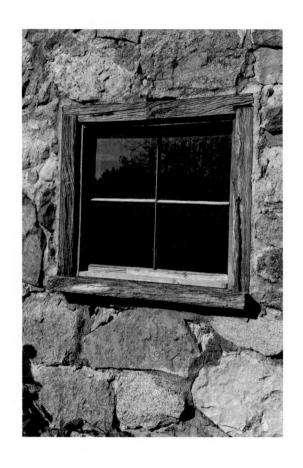

Easy Essay CCCVI

There is bribe for neither
Wood nor Stone; they will
testify.

EASY ESSAY CCLXXIX

for George and Maggie Wruck

While an Economy leans on novelty, vogue and contrived obsolescence, a Civilization rests on conscience, permanence, and maintenance.

Easy Essay LXXXII

Scoff if you will but building is not without its own theology, and he is thick in deed who holds that sin will not avail itself between the first shovel of dirt and the setting of the last nail.

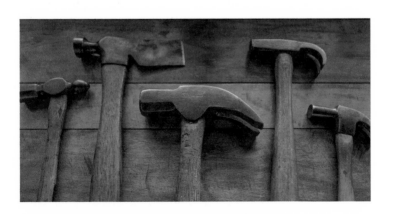

EASY ESSAY CXVII

Morally speaking, modern man
said *to hell with plumb bob and level*
and then was bewildered when all
the marbles gathered by the
baseboard in the living room.

for Bernice Goulet

By design the holy make
themselves small to allow for
beauty to come into view.

EASY ESSAY CLXXXVI

How precious the lesson
we receive from nail as it
falls from view to serve.

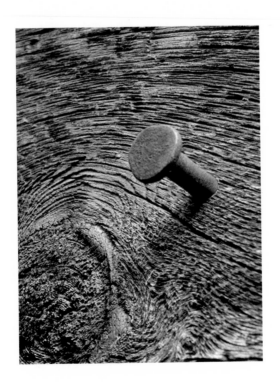

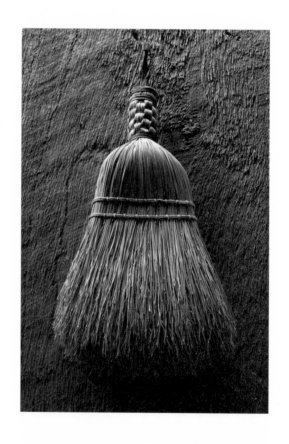

EASY ESSAY LXIX

Beauty resides
at the intersection of
Harmony and Utility.

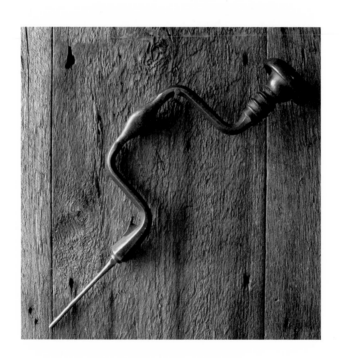

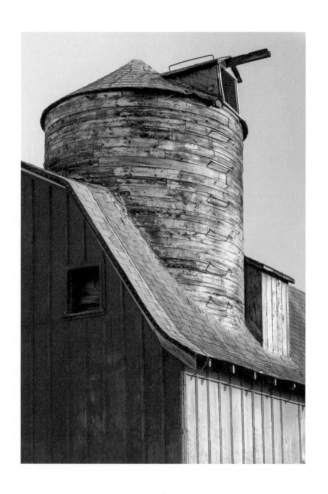

A Treatise on Travel

You drop that on your way from
the Taj Mahal you stopped at the
Louvre and the Cloisters too—

but I have been to Heim's Mill,
seen the tools of Angus Moeller,
the barn of Martin Himmelgarn
and know not envy.

Shoddy work is the blood
trail of Time wounded.

EASY ESSAY CXCVII

for Bill Schwartz
(1940–2016)

Who better to testify for Truth
than the Craftsman—when he was
in the moment?

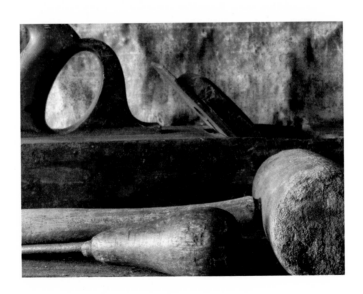

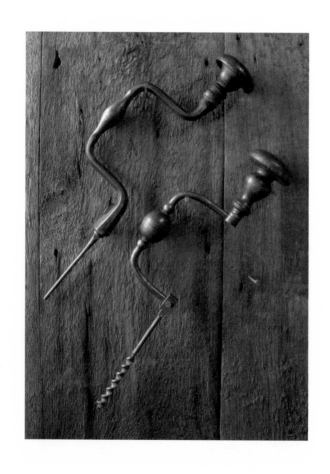

EASY ESSAY CCXCVIII

More meaningful than the
blood that entitles me to say *heir*
are the tools of my father that
enable me to say *successor*.

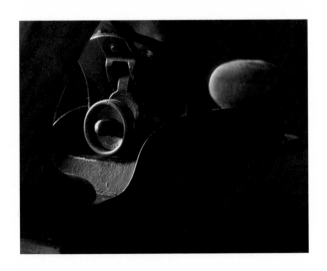

ON THE ART
OF SACRIFICIAL BUNTING

for Leonard Hansen
(1918–1984)

My father raised eight children
when milk sold at a loss for three
dollars a hundred weight as did
butcher hogs for thirteen cents a
pound. It seems he spent his whole
life on the lookout for rusting
machinery and *weak-fielding
pitchers*. He learned early on what
all poor folks come to know; how
precarity will dictate swing.
One summer Sunday, with corn
and oats withering in the field and
mortgage due, he drank too much
dandelion wine and threatened *to
tear the cover off.*

Monday morning found him in the
barn again at dawn, *choked up* and
waiting for the first low pitch.

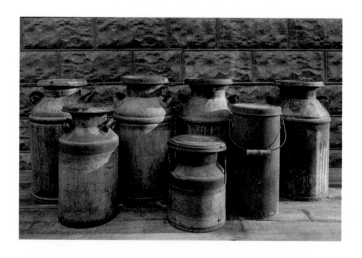

Putting Up the Third Cutting of Hay with Homer at Eighty-Four

Round following round
under an unforgiving sun

an old man stacks
the meadow's generous gift
on the hayrack five high—

his second breath employed now
in keeping one step out in front
of failure.

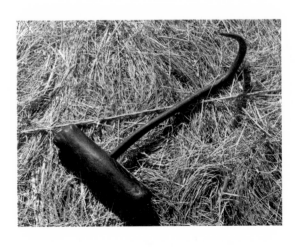

"A man cannot see enough of the world from his backyard—that is why God made the front porch."

Homer Sod

Homer died in the same bed in the same room of the house that he was born in ninety-nine years earlier.

In a time like ours of squander, spillage and global gallivant, a man like Homer is reduced to laughing stock, brunt and butt.

However in a more thoughtful time, one where *right thinking* might find harbor, he would be, I contend, our patron saint of reason.

EASY ESSAY CXCVI

for Frank Pallansch

Take lesson from the common crow as he chores in the wake of waste, as from the swallow as he builds with economy and grace, and too, always take note of the Vesper Sparrow.

Do these and it will be said that you were a product of the best schools.

A Treatise on Erosion

for Wendell Berry

Simplicity, Stability and
Affection are the roots of a culture
assigned to hold the topsoil of the
moral high ground in place.

THOUGHTS ON A PLOW
FOUND IN A BOXELDER TREE

On the deserted farm of Gottlieb
and Clara Grundman is a one-bottom
John Deere plow grown into a huge
boxelder tree. The tree's muscular
limbs grip the levers and beam, while
burl and bark hold tight to moldboard,
coulter, and share. I cannot pass by
this inter-species wedding of iron and
wood without wondering—
did the plow after many seasons of
ripping and tearing, tire of a furrow-
view and opt for a more lofty one—
or did the old tree tire of the genocide
and clutch the plow to make the world
safe for her offspring once again?

NUDE

The leaves of the maple tree
conspired to fall on a still day;
that night she stood
naked in moonlight;
a disheveled golden robe
at her feet.

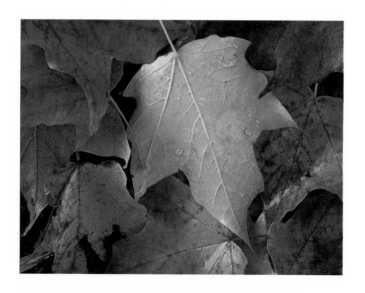

Along with humility comes the awareness that we were ushered to a restricted-view seat.

Easy Essay CXIX

From the same window
where it is that the proud
see *entitlement*, the humble
will see *debt*.

Easy Essay CVIII

for E.F. Schumacher
(1911–1977)

Always it is ours to be
on the alert for the sound of
an Economy missing—the one
running on a blend of Horatio
Alger, Napoleon Hill, and Dale
Carnegie that is not throttled
by Jesus Christ.

"We saved some for you."

On Moderation

Thoughtfulness
has scheduled us to speak
after we are gone
to all those who will follow us—
what remains is to decide
if what we say will be
by *design* or by *default*.

Easy Essay CXXVI

What is today's *right*
beyond yesterday's *need*
that tired of an alarm clock?

EASY ESSAY CCXCVI

Ownership can only be
redeemed by stewardship—
that is to say a *covenant*
made up of *regard* and
reverence for all living things
from bud on.

EASY ESSAY CCXCIII

It is by way
of *private property*
we ground freedom.

EASY ESSAY CLXXXVII

Freedom is that inefficient system
that will employ a hundred chains
where slavery would but one.

EASY ESSAY II

Freedom is seldom stolen—
almost always it is abandoned
like demanding puppies on
the steps of a shelter.

EASY ESSAY CCXX

Unlikely is man in his quest for
speed ever to invent a machine half
so fast as his own dignity slipping
away in the process.

EASY ESSAY CXLIII

Mindless Travel is our last
Sacrament—Petroleum our
one remaining Holy Oil.

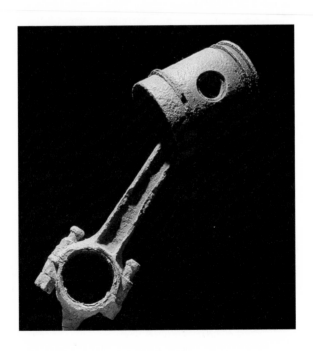

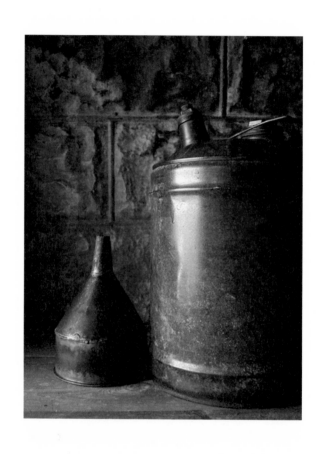

EASY ESSAY CVII

No other difference is so fraught with consequence as is whether we will *brake* and *pull over* or merely run out of fuel and coast to the side.

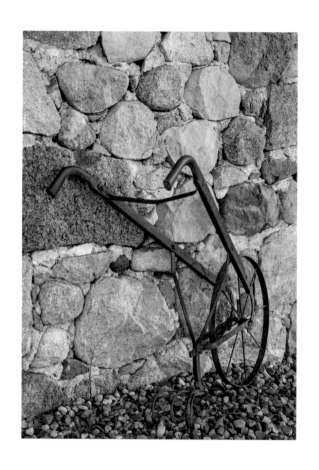

Easy Essay CCCX

with skyscrapers,
lunar landings
and babble in mind

It is an urban posture
that looks to the sky—

as does a rural one
to the earth.

Easy Essay XC

No small number now seek to
make the globe a single color;
when having studied darkness,
I would add a hundred colors to it.

EASY ESSAY CCCI

In defense of things
provincial and parochial

It is by a secular gearing that we
are tumbled about now with the
design of wearing away the edges
of both our nativism and our faith.

EASY ESSAY CLXXXVIII

When God saw that
Ignorance could not serve Him
and that Knowledge would not,
He created Mystery.

Surely none
but a God on our side
would place so many clues
in plain view.

Easy Essay CXCIV

No other ground
is so fertile for pharmacy
as is where we choose
to bury God.

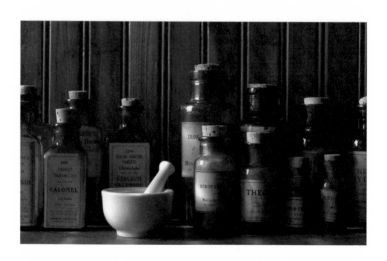

We ought take more away
from the testimony of Nostalgia
for she has no history of perjury.

Easy Essay CCCXI

for every child

My prayer for you, child, is a home
where *leaving* will always be forced
to travel with *longing* and from there
a life where Hope is eager to call
cadence for your enthusiasms.

ON THE LOSS OF BROTHERS AND CHEVROLET PIES

One summer day
before the world took us away, my
brothers and I wandered off to
Beehler's Bog. We built a stove
there out of mud and willow
branches, with oven, burners and
knobs. That afternoon we baked
little cakes, mud muffins in Kerr lids,
hazelnut cookies in bottle caps,
covered a sod counter with hubcap
pies.
We were almost back home when my
brother Hank remembered that we
had left a burner on—
where upon all went racing back.

Forty years later I return to
Beehler's Bog where neither that
mud stove, my brothers, nor I are to
be found.

Résumé

In pursuit of a decent competence

To spread the manure, to plow
and sow, to tamp the earth above
the seed, to pick the stones, to
encourage the reluctant calf at
midnight, to bottle-feed the orphan
lamb, to mend the fence, to pick the
stones, to read the crown on board
and plank, to make level threshhold,
soffit, and sill, to clinch the nail
against the grain, to pick the
stones, to listen for hurt, to
recognize enough, to honor the
elder—

these were our lessons and should I
tell who we *studied under* there
would be no big names to *drop*, for
ours was a campus of barns, sheds,
granary, and shop—
the faculty blue-collared.

Easy Essay CXXXVIII

Deep in the bowels
of every machine
is a hopper for souls.

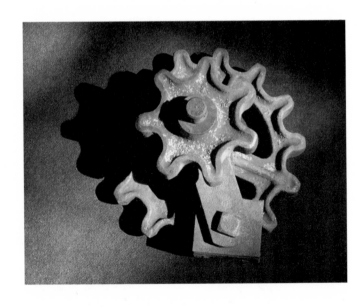

EASY ESSAY CCXCI

Aptly named
was the Combine
for all in one it harvested:
Communication, Communion,
and Community.

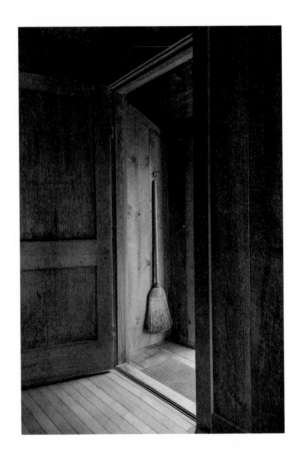

Easy Essay CLXXIX

for Nicholas Reuter

A knowing physician
will yet prescribe *roots*—
that is to say the medicine
of place.

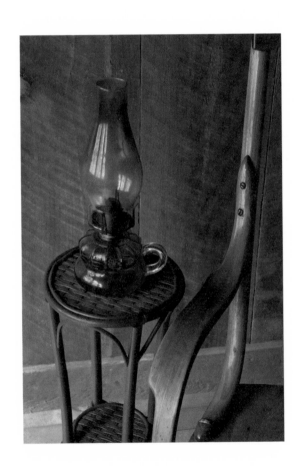

for John and Clara Storkamp

Too readily we assume of
others that they have *fallen
behind* when perhaps it is
that they saw ahead and
chose behind.

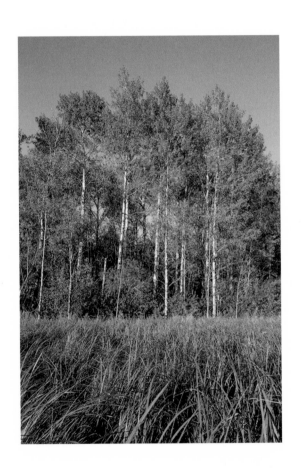

for David Majeski

H ow one's soul does ache now
for those places that invite whisper.

EASY ESSAY CCXCV

Simplicity is the Inn that
provides a cot for the Eye
and a hammock for the Ear.

All of sound is bound
by the beauty of silence.

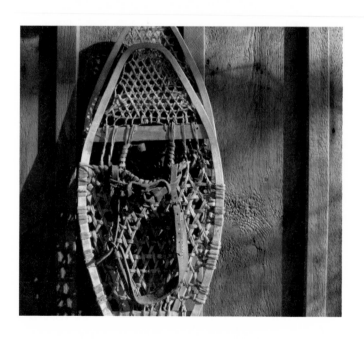

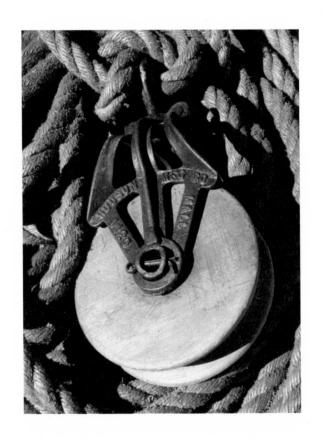

EASY ESSAY CXXV

The computer with all its capacity
cannot convene for my soul's sake
those things the humble pulley
manages.

Give me a pond,
any pond, and you
can have Lake Superior.

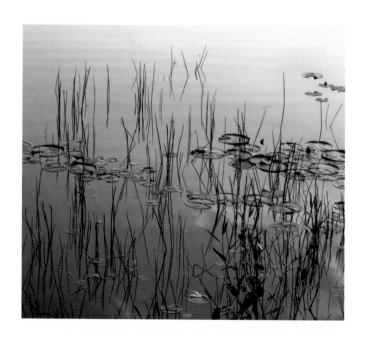

MANIFESTO

I have seen enough and now when
I see the snout of Science near the
trough of the unknown, I go ahead
to warn the frogs.

Sadness is a descendant of the Melancholy family whose tradition it is to invite Slowness along with the hope that Slowness will usher in Stillness as Stillness will Silence.

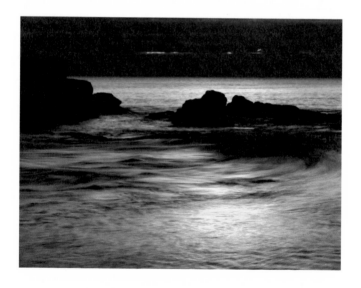

EASY ESSAY CCLXXXIII

Conscience was assigned to
never leave us alone, and so it is
that we must live our self.

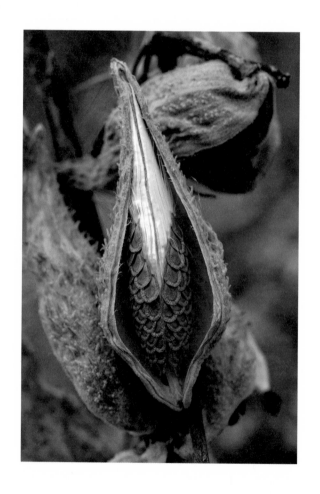

TAKING NOTE
OF THINGS LOWLY

The flower garden with
its fountains and legions of
conscripted hues is nothing
to Pathos, for she is employed
by the Soul and allied herself
long ago to the lone weed
volunteering in the ditch.

A BOURGEOIS VIEW

From the Sun Parlor
a dozen white roses
in a crystal vase
look down on dandelions
huddled on the front lawn
like refugees awaiting
an unknown fate.

Never is Leaf so vain as in Spring
when she conspires with Sun to
form in her own image, a tiny lake.

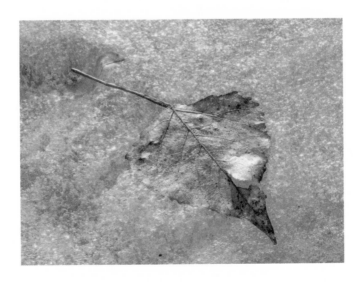

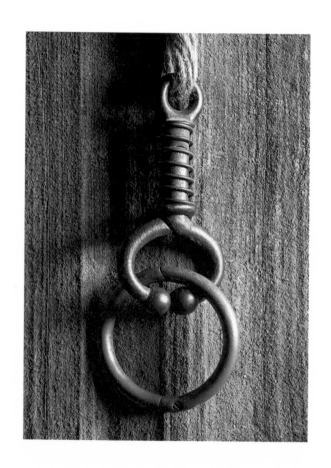

EASY ESSAY CXXIII

How costly it is
to lean on the ledger
that fails to assign
a column to beauty.

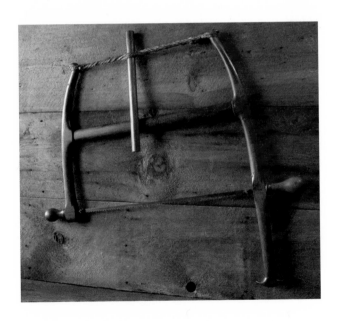

EASY ESSAY CCLXVII

for Glenn Good Thunder

That part of us that will inform
the Feet that they must share the
rug with the Eyes and the Soul,
we call art.

That we
need never bury Beauty
we owe to memory.

A Treatise on Extravagance

Excess is always pursuing Beauty,
unaware that Beauty long ago
gave herself to Enough.

Year in and out it is
we take our best harvest
off our *common ground.*

On the Odor of Surplus

Few things go bad so quickly as does surplus. And so it becomes ours to remain on guard for both a weak imagination and a wanting definition of brother.

Emptiness can always be found where there isn't room for another thing.

EASY ESSAY CLXXXIII

For the Pilgrim, all of physics
has but one necessary lesson:
What we pick up will weigh us down.

To what avail
a surplus of everything
minus the clevis of Love?

EASY ESSAY CCLXXXI

for Andy Tauber
(1915–2005)

The fate of goodness does not
lie with the many who need say
we knew, but rather with the few
who can say: *we did*.

COMMUNION AT THE
LITURGY OF IMPLEMENTS

for Vincent Ludwig
(1923–2011)

Oxygen deprivation at birth
dropped Vincent off in a confusing
place, and by the time he learned
to tie his shoes
they were work boots.

I like to recall the times now
when thunder was the church bell
that summoned my brothers and me
along with Vincent
to the tool shed on rainy days.

Together to the tune of small talk
we scraped dirt and dung
from shovels, hoes, and forks—
brushed used tractor oil onto the
parts inclined to invite rust.

Our liturgy always ending with the
oiling of our boots—

> Vincent perched like a Saudi
> prince on the wooden stool by
> the emery stone with my brother
> Wendell rubbing oil onto his
> boots with a cotton rag.

This is the memory I guard now,
for it equips me like none other
when up against the ruthless one
of Vincent's lot.

for Meridel Le Sueur
(1900–1996)

Wool and cotton,
silk and satin, all will
garner my attention—

however, to hold it,
you must wear earth.

TO THE BLACK MAN
IN LINE AT SIMONSON
LUMBER YARD

for Abraham P. Cation
(1942–2012)

Your eyes spoke honestly for you
when they caught me staring—

I hope mine did likewise, revealing
how much I liked your fine black face.

EASY ESSAY XXXVIII

for Margaret and Marina

With Love none is too old,
too small or of the wrong color,
for She has a quilter's eye.

THE LADY
WHO LOVED FERNS

for Margaret (Ludwig) Hansen
(1920–1993)

At eleven and the oldest of seven,
my mother slipped on the death of
her mother into adulthood unnoticed.

For the next sixty years her life was
chauffeured by the needs of others.
There was in her soul neither bin for
vainglory nor pretense. Her only
travels were from Caring to Devotion
and from Goodness to Grace.

Like all saints she cared little for the world—that is to say the whole— satisfied that she had been assigned the particles.

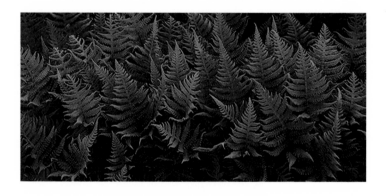

Seasons are the remedial
teachers assigned to remind
a thick people of their sojourn.

October *moans*
and all is on schedule.

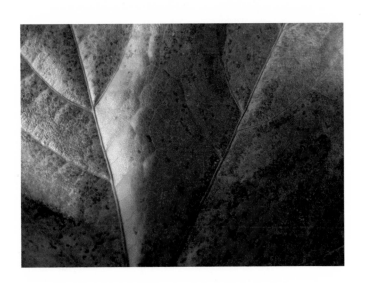

EASY ESSAY XIII

To what avail the allying of
oneself with a hundred causes,
while the thistle in his own back
yard goes to seed?

EASY ESSAY CCCVIII

It is poverty of a sort not to
want to be back home by dark.

EASY ESSAY CCXXVIII

There is no final payment
on the myth that one can
husband from a distance.

"I am the vine, you are the branches."
(John 15:5)

remembering Fred Weiner
(1904–1998)

Fred always wore
a white shirt and tie
to daily Mass—

the same white shirt and tie
that he wore when working
in his orchard.

I am thinking now how perhaps
it was that his Franciscan soul
provided him no perch from which
to view the end of things sacred.

Easy Essay CCLXVI

While Prudence will separate the
bad from the good, it calls on Love
to see the good that yet remains in
the bad.

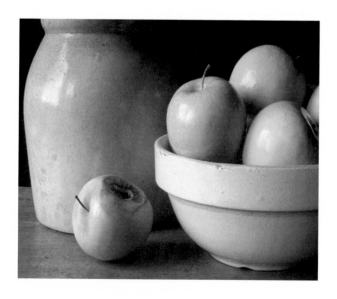

"We is called, not to fill a hundred bins but just
to stay one step out in front of shortage."

OLD MAN BURNETT

for Leander Burnett
(1883–1967)

Sixty years later I can still see Old
Man Burnett making his way from
garden to garden with his team of
sorrel mules and one-bottom John
Deere plow.

"Dem tractors is too dang hungry—
their lights eat up the nights and their
payments all the Sabbaths."

Old Man Burnett never did second
Modernity's motions for speed and
bigness, and it remains the shame of
our village how little of lesson we
took from him.

Until he died, each spring and fall
he moved among us like the
question—

did we want to reconsider our
choice of *scurry* for his of
sacramental pace?

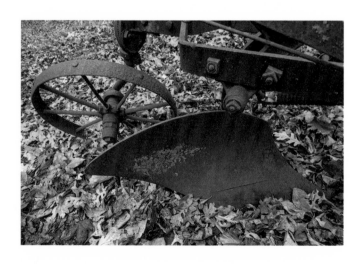

The Lady Who Went Out of Her Way

for Jean (Siebels) Hoffmann
(1911–2014)

Jean was a daughter, sister,
wife, mother, grandmother,
great-grandmother, and, thankfully, a
mother-in-law. I cannot summon her
now in my memory but that she is
going *out of her way* for others.
Like with all saints, we are left to
wonder what *her way* might have
been. I, myself, hunch that her way
had something to do with the
carving of wood, poetry, and
playing the piano—that was before
a good man named Carl, five
children, and a two-acre garden took
her *out of her way.*

While the cynical might diagnose
loss here, or even tragedy, I choose
to rejoice and to see another thing
—I see a lady going *out of her way*,
sensing that—*out of our way* is
where Love takes us.

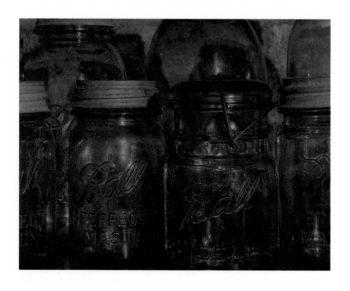

ON CARING FOR CATTLE

"God be with you and if He isn't,
get back to me—I'll talk to His Mother."

Brother Willie O.S.B.
(1916–2009)

The last book
Brother Willie gave me
was about dairy cows—
about the feeding and care of
Holsteins, Guernseys, and Jerseys.

I keep that book on my shelf
between Augustine and Aquinas—

not because it is a holy book
but because it was once
owned by a holy man.

for Wayne Smith

Thoughtful
it was of God
to stock in every place,
one to make us ponder
and another
to make us laugh.

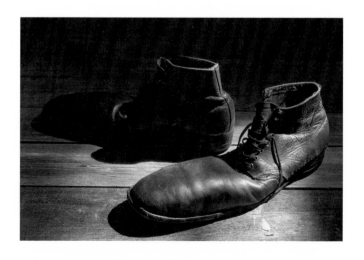

SPARROW

for Jeanette

Each Spring the Robin
is given a hero's welcome,
but I have no interest in him;
my concern is for the Sparrow
that stayed the Winter.

THE LANGUAGE
OF MARRIAGE

Intimacy insists on employing her
own words—words that the two will
take with them at the end—words
that in the interim Devotion and
Discretion will stand guard over
to ensure that no third person
on earth gains fluency in them.

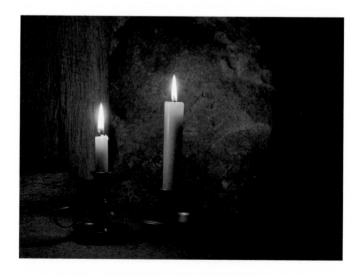

REQUIEM

Homer was still dancing
in December when Death cut in—

we laid him out in his bib overalls
and black oxfords,
as if Death were but a synonym
for Intermission.

EPITAPH

Here lies Homer Sod
who never was to Las Vegas,
Disneyland, or Hollywood—

and that he loved to laugh,
what more need be said
on his behalf?

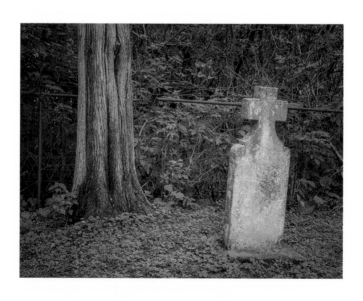

"Let us search and try our ways,
and turn again to the Lord."

Lamentations 3:40

How small
the part of our weariness
that cannot be traced
to having gone around
the things we should
have been above.

EASY ESSAY XXIV

Sleep is not a gift—
it is a by-product.

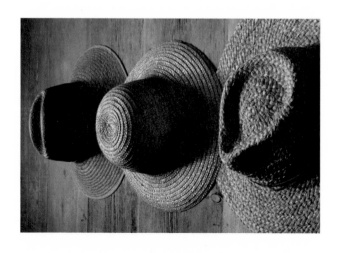

Easy Essay CCXXX

Spill Pride on Truth and there is no telling how many pages will stick together.

Better than to have read
a thousand books is to have
lived one story well.

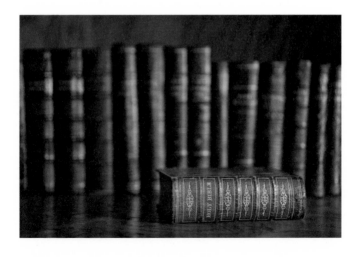

Easy Essay CCLVIII

Death is not about a boulder
waiting for us at the end, but rather
a thousand pebbles along the way.

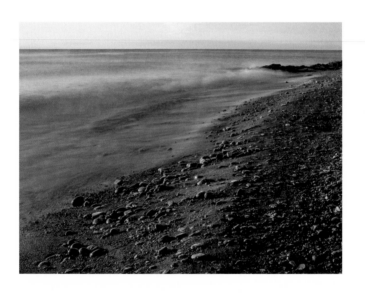

Easy Essay CCCXII

To have weighed with
compassion the circumstance
of all God's creatures, to have
neighbored well and to have
been loyal to a small place—
these ought suffice in our wake.

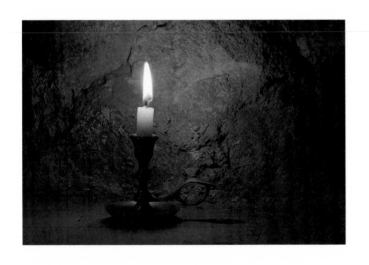

136 County Road 120
Le Sauk Township

There is balm in the memory of how it was over time that a mere address came to be synonym for sanctuary.

He who goes the farthest
is closest to home.

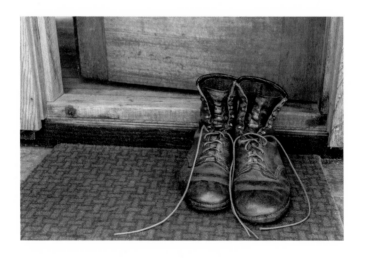

THE CANON

"Let us go into the fields . . ."
Song of Solomon 7:12

They were small farmers all—
thick-fingered men and women
who turned in tandem to God
and the earth for their solace
and sustenance.

Their lives were marked as much
by failure and loss as they were
fruition and gain. In their living they
were graced with enough of
clemency, blush, and umbrage to
satisfy love, modesty, and justice.

It comes down on their side now
that you would not recognize any
of their names—for of all the things
that they set out to make, History
was not among them.

JVH

ACKNOWLEDGEMENTS

A very special thanks to Chuck Norwood. Those who know Chuck personally and of the infectious enthusiasm he brings to an undertaking will understand when I say that the reader would be rash to assume his contribution stopped at the photography. I shall forever treasure our yoked undertaking and the friendship that ensued.

A special thanks to Corinne Dwyer and Curtis Weinrich at North Star Press for their ever thoughtful and accommodating ways. My gratitude as well to Don and Jeanne Molloy, Joe Preusser, and Ralph Dehler, just a few of the many folks who opened and closed gates in bringing this book forward. Thank you to Peter Maurin (1878–1949), longtime friend of Dorothy Day, whose idea Easy Essays first was.

And as always, Jeanette, the girl who made my gift to her of a twelve-ounce Stanley hammer on our third date my best investment ever.

ABOUT THE AUTHOR

Photo by Don Hoffmann

J. Vincent Hansen grew up on a farm east of Sauk Rapids, Minnesota. After high school, he spent three years in the Army followed by seven years working in East Africa as an agricultural volunteer with the Maryknoll Fathers. He is the recipient of the 1990 Loft-McKnight Award for Poetry, and a 2009 Bush Artist Fellowship in Poetry. In addition to the books, *Blessed Are the Piecemakers* and *Without Dividend in Mind*, he is the author of the multi-media play, *The Wedding of Tomorrow and Sorrow*. He lives with his wife, Jeanette, on five acres near Sauk Rapids, Minnesota.

ABOUT THE PHOTOGRAPHER

Photo by Kristi Curme

Chuck Norwood makes his home in St. Cloud, Minnesota, where he is employed as technical director for the Paramount Center for the Arts. He is a member of the Artist Guild of Central Minnesota, the Great River Arts Association of Little Falls, and the Arts Alliance of Elk River, Minnesota. Chuck is the recipient of the 2011 McKnight Individual Artist Award and the 2014 Career Development Grant from the Central Minnesota Arts Board.

Along with my thanks to Jerry and Jeanette for bringing me on board, I especially want to thank and dedicate this work to my daughters, Kristi and Brittany, with all my love . . . for all of theirs.